The Coloring Book of Circular Patterns

Deb Schense

Acknowledgments

Front and back cover by Deb Schense of Big Fox Publishing.
All rights reserved
Printed in the U.S.A.

If you enjoyed this book, please leave a review online. To see other books by the author visit: www.bigfoxpublishing.com. Some of the images were by Speedy McVroom from Pixabay and others were a modified by Deb Schense to create new patterns. Enjoy!

ISBN-13: 9781093977646

Big Fox Publishing
P. O. Box 170
North Liberty, IA 52317
www.bigfoxpublishing.com
© 2019 by Big Fox Publishing

About the Author

Deb Schense is a Waverly, Iowa, native. She graduated from Kirkwood Community College in Cedar Rapids, Iowa, with an associate of applied science degree and the University of Iowa in Iowa City, Iowa, with a bachelors degree in management information systems. Deb worked in computers for more than twenty years before switching gears to writing and editing. She wrote *Eastern Iowa's Historic Barns* and edited another barn book, *Barns Around Iowa,* and has edited numerous ethnic books and cookbooks while contracting for Penfield Books.

She started her own publishing company in 2016. Since that time she has published a memoir for the Cedar Rapids mayor, a book about a Cuban family that escaped Cuba, a decorative Czech book about decorating eggs, several rosemaling books, and coloring books. She currently lives in North Liberty, Iowa, with her husband and son. For more information please visit her website at: http://www.bigfoxpublishing.com.

—35

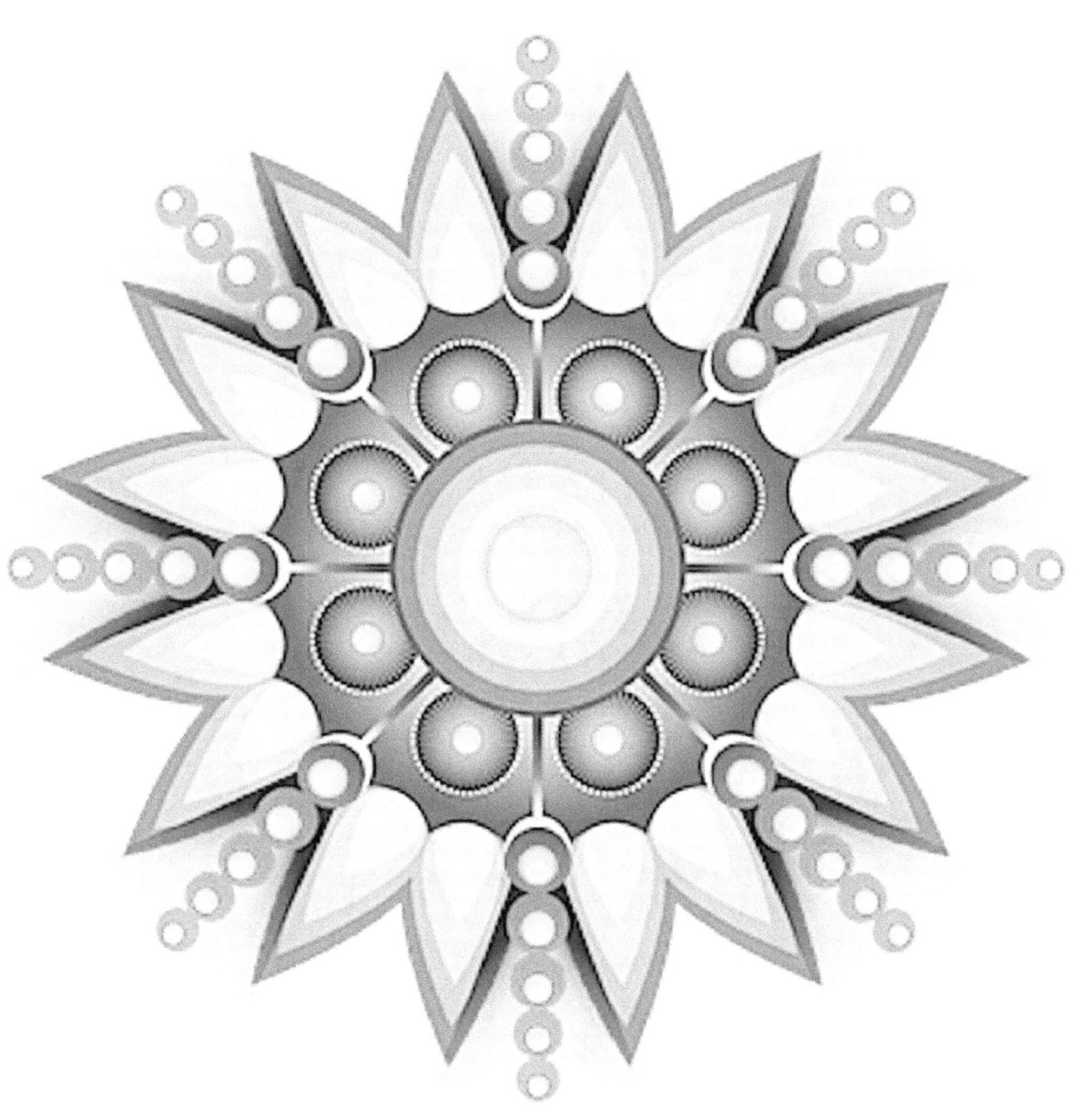

If you enjoyed this book, please leave a review on Amazon.com. Thank you!

www.ingramcontent.com/pod-product-compliance
Lightning Source LLC
Chambersburg PA
CBHW080841170526
45158CB00009B/2601